COLOR
HARMONY
Naturals

ROCKPORT

First published in the United States
of America by
Rockport Publishers, Inc.
33 Commercial Street
Gloucester, Massachusetts 01930-5089
Telephone: (978) 282-9590
Facsimile: (978) 283-2742
www.rockpub.com

ISBN 1-56496-719-0

10 9 8 7 6 5 4 3 2 1

Design: Francesco Jost
Layout: SYP Design & Production
Cover Image: Francesco Jost

Printed in China

COLOR
HARMONY
Naturals

A GUIDEBOOK FOR CREATING GREAT COLOR COMBINATIONS

GLOUCESTER MASSACHUSETTS

ROCKPORT PUBLISHERS

Martha Gill

Contents

Introduction

Color is complicated. The multitude of color theories, systems, concepts, and definitions is mind boggling. The scientific aspects of color alone could fill volumes; from Isaac Newton's first circular diagram now known as the "traditional" color wheel, to today's color-conscious corporate culture which has long employed the services of professional colorists to predict best—selling colors and color combinations. Predictions are constantly changing, though, so finding the latest "in" color at any given moment could take a lifetime. And if you are like most people, you have made more than one color blunder. Maybe even dozens upon dozens of color mistakes. In order to be able to select an optimal color palette, it's critical to understand just a few basic color principles.

This book is created to make color selection and picking palettes easy. So easy that color will become a vehicle for you to communicate whatever it is you want to say about you, your home, your crafts, your design project, or your product. Think of this book as a working tool with color swatches to tear out, palettes to review, and advice to consider. Here you will find the very basic principles of color theory explained in an easy—to—understand format that focuses on mixing natural color combinations. Also included are fourteen "moods" based on a natural palette, harmoniously matched with hundreds of color combinations from rustic and homey to sophisticated urban and minimal palette selections–all inspired by the bountiful colors of nature.

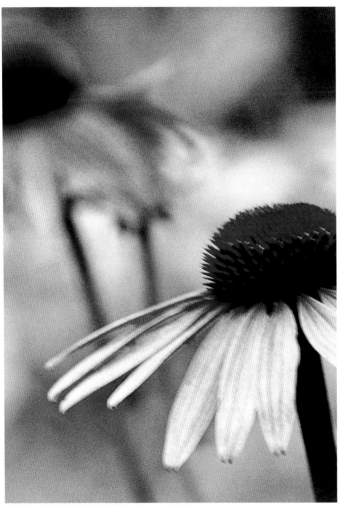

Varying Color Systems

Different color systems are used by artists, printers, and scientists.
Artists and painters use three primary colors—red, yellow, and blue to
create all other colors (this is the system discussed in this book).
However, this book is printed using the print industry's method of
combining tiny dots of cyan, magenta, yellow and black to build
specific colors through dot patterns that our eyes naturally "mix" and .
interpret as a wide array of colors. Scientists use an entirely different
system based on light where red, green and blue are used as the
primaries. An example of this color system would be the colors
generated on a computer screen monitor or television.

ABOUT Naturals

At first the term natural colors may conjure up thoughts of hemp, jute, unbleached linens, and a veritable truckload of objects that are off-white, ecru, or presented in buff shades. A look outdoors at true natural color reveals a far wider spectrum—a multitude of yellow grass greens, peaty wood browns, lemon citrus tones, and heavenly sky blues. Natural colors are the colors of the planet. From seascapes to landscapes, inspiration for a natural color palette is all around us. In fact much of what we have come to regard as regional color (or the particular colors that a region uses repeatedly) have their origins in the landscape of the region. For example the colors of the American Southwest are found throughout southwestern cities, displayed on buildings, in fashion and artwork, but originally were derived from the region's natural surroundings of desert, sky, and plain.

© Paul Mason/Photonica

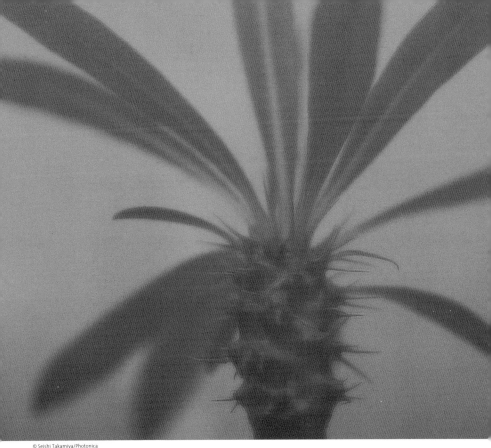

© Seishi Takamiya/Photonica

In this book you will find the standard tried and true natural palette with the expected yellow to orange toned buff hues and earthy browns that are familiar to you. In addition you will find a wide array of natural colors from which to build a palette from buoyant blues and aquamarine hues influenced by the coastal sea to deep, dazzling indigo colors of the night sky. The range of natural colors isastounding, to fully grasp the spectrum of a natural palette simply observe the abundant and colorful world around us.

THE Color Wheel

The twelve segments of the color wheel consist of primary, secondary and tertiary hues and their specific tints and shades. With red at the top, the color wheel identifies the three primary hues of red, yellow, and blue. These three primary colors form an equilateral triangle within the circle. The three secondary hues of orange, violet, and green are located between each primary hue and form another triangle. Red-orange, yellow-orange, yellow-green, blue-green, blue-violet, and red-violet are the six tertiary hues. They result from the combination of a primary and secondary hue.

Constructed in an orderly progression, the color wheel enables the user to visualize the sequence of color balance and harmony.

PRIMARY

SECONDARY

TERTIARY

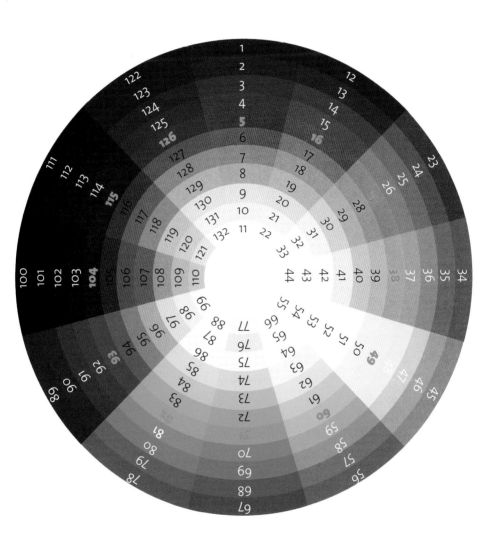

Natural Color Chart

1	12	23	34	45	56	67
2	13	24	35	46	57	68
3	14	25	36	47	58	69
4	15	26	37	48	59	70
5	16	27	38	49	60	71
6	17	28	39	50	61	72
7	18	29	40	51	62	73
8	19	30	41	52	63	74
9	20	31	42	53	64	75
10	21	32	43	54	65	76
11	22	33	44	55	66	77

78	89	100	111	122	133	144
79	90	101	112	123	134	145
80	91	102	113	124	135	146
81	92	103	114	125	136	147
82	93	104	115	126	137	148
83	94	105	116	127	138	149
84	95	106	117	128	139	150
85	96	107	118	129	140	151
86	97	108	119	130	141	152
87	98	109	120	131	142	
88	99	110	121	132	143	

Naturals

Color is energy, created by life giving light. It is no wonder color is also reflective of emotion. Whether combining naturals with other natural hues or with pastels, brights, metals or woods understanding just a few of the basic color principles is the first step toward achieving positive results.

Consider the color wheel, traditionally divided into two parts—a warm side and a cool side. The warm side of the color wheel, featuring reds, oranges, and yellows, is considered active and exciting. The cool side spans from green to blue to the coolest violet hues and is considered passive and calming. Each side embodies a specific set of emotions. The primary colors in painting are red, yellow, and blue—the colors from which all other colors are created. Secondary colors are created when two primaries are mixed together, orange, green, and violet. Lastly the tertiary colors are red-orange, yellow-orange, yellow-green, blue-green, blue-violet, and red-violet. By understanding the structure of the color wheel you can begin to select colors that are natural in origin using one or more hues to create and mix successful color palettes

© Takeshi Odawara/Photonica

within basic color schemes.

A monochromatic color scheme is one of the simplest to create, just combine any color with its tints and hues. Naturals work particularly well within a monochromatic scheme—they harmonize and flow beautifully. Imagine the golden brown variations of each grain of sand on a warm summer beach or the multitude of sun yellows that can be blended and mixed from the lightest creams to glowing deep ocher tones to vibrant chromes.

Another successful scheme for naturals is to select any three consecutive colors on the color wheel. For example, try yellow, yellow-green, and green—when used together with all their various tints and hues

they will inevitably create a flow of natural color like the rustle of new spring leaves illuminated and enlivened by each gust on a sunny day. Combine a hue with its direct opposite on the color wheel for a basic color scheme that is called "complementary". Use the color to the immediate left or right of its complement on the color wheel to create a bit more complex and sophis-ticated mix that is known as a tertiary color scheme. To envision this scheme imagine a field of yellow buttercups set against a blue-violet sky or darkening green hills set dramatically set against a brilliant red-orange sunset with violet streaked skies.

The creams, honeyed browns, and off-whites that are so often associated with a natural palette are perfect foils for breaking up large expanses of color. These basic natural hues are a calming influence on just about every color palette. When mixed with pastels such as pale lavenders and wispy sky blues they become even more restful and soothing. When paired with vivid brights they provide a steady stable backdrop that is absolutely neutral. Paired with other brighter deeper naturals such as forest greens and earthen reds they emulate the beauty and expanse of the great outdoors. It's amazing how the personality of a color will change when it's used in combination with different materials. For example a sky blue when paired with a polished pine is modern, with rosewood it's sweet, and with darker oak, historic. Use the versatility of natural colors to mix palettes and create color schemes that are as enduring as the planet.

© Gina Boffa/Photonica

Creating Your Own Palette

Professional graphic designers use tear-out color swatches to select colors such as
Pantone's color matching system with over 3,000 colors that are identified
numerically or they often make color selections from the Japanese color system called
"Toyo." Use the color swatches in this book combined with one of these systems or if
needed enhance with paint swatches from a paint or hardware store to develop your
own personal palette.

Warm

_(RED)

Red was one of earth's first pigments to be discovered and used as a stain for coloring and decoration. Faded with time, historical artifacts and paintings created with dyes made from natural cinnabar, vermilion and other minerals mined from the earth once displayed much brighter reds than we typically view today. Mix these earthen reds with other plain pigments like the rich yellow brown tones of saffron, ocher, sienna and ruddy umber. Dark woods such as teak, mahogany, and cherrywood bring out the warmth and richness of this hue. Orange based adobe, amber, and terra-cotta also blend easily with natural brown-based reds.

© Robert Ripps/Photonica

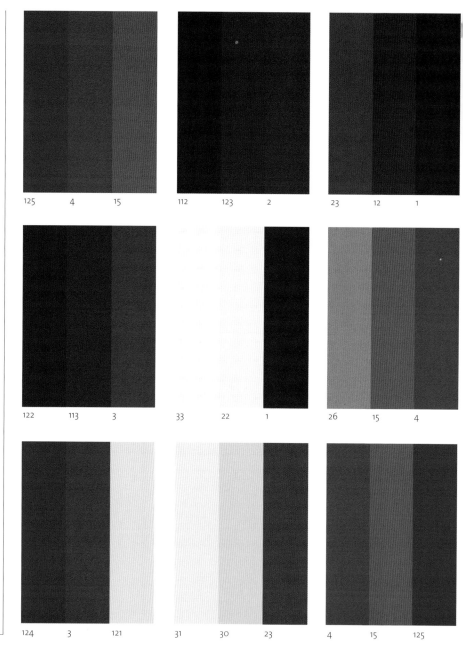

125	4	15
112	123	2
23	12	1

122	113	3
33	22	1
26	15	4

124	3	121
31	30	23
4	15	125

1	67
3	69
76	11

56	3
78	1
3	57

2	88
11	65
78	4

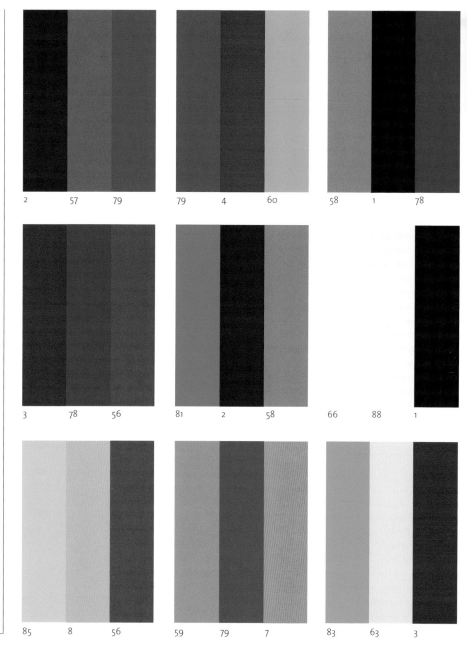

2	57	79
79	4	60
58	1	78
3	78	56
81	2	58
66	88	1
85	8	56
59	79	7
83	63	3

4 133

3 137

1 139

3 142

4 147

1 5

34 23 2

122 111 4

24 23 2

Rustic
(RED-ORANGE)

Be inspired by natural objects and create rustic color combinations that give out warmth. A handful of soil, scattered acorns, and newly fallen leaves are a constant reminder that man's first colors came from the earth. Natural colors work best when they are simply being themselves—rough and textured surfaces like burlap, linen, and unbleached fabrics can be combined with organic untreated woods for interiors that bring the outdoors in. Add ocher, ruddy oranges, and touches of red for the colors of fall fires and roasted chestnuts. Rich, full berry tones like mulberry red, flame orange and crimson blend well with the many honeyed shades of nut brown.

© Arthur Tress/Photonica

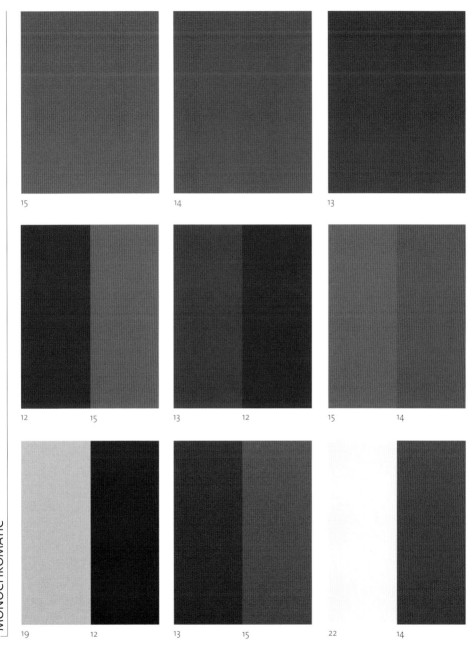

15

14

13

12 15

13 12

15 14

19 12

13 15

22 14

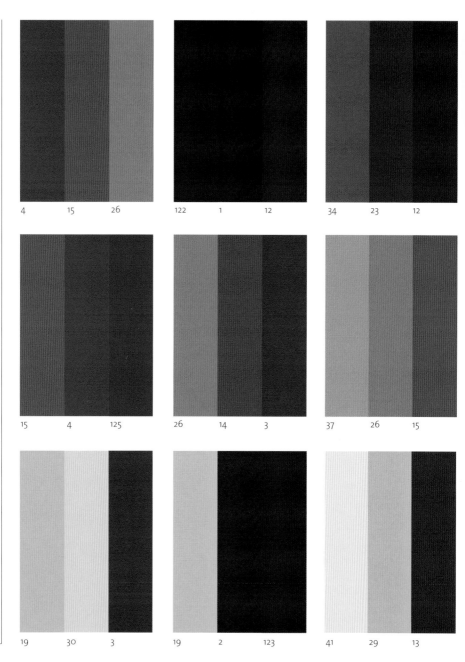

| 4 | 15 | 26 | | 122 | 1 | 12 | | 34 | 23 | 12 |

| 15 | 4 | 125 | | 26 | 14 | 3 | | 37 | 26 | 15 |

| 19 | 30 | 3 | | 19 | 2 | 123 | | 41 | 29 | 13 |

78 12

15 87

79 13

15 89

12 67

19 97

73 15

13 90

19 69

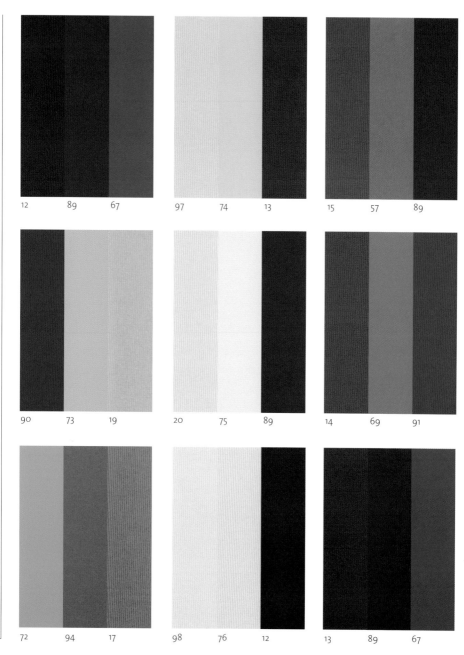

12	89	67
97	74	13
15	57	89

90	73	19
20	75	89
14	69	91

72	94	17
98	76	12
13	89	67

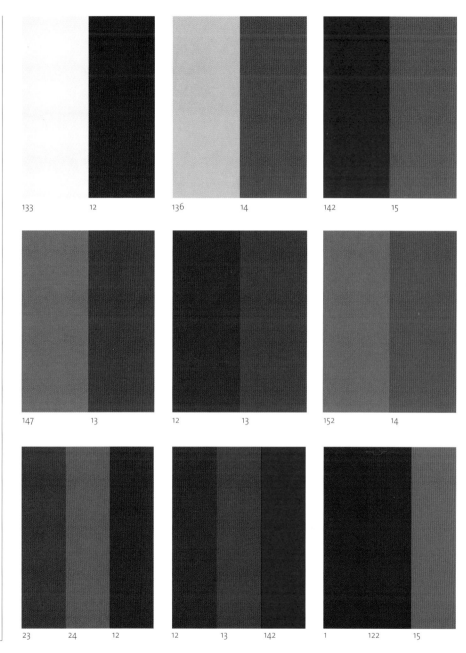

133 12 136 14 142 15

147 13 12 13 152 14

23 24 12 12 13 142 1 122 15

Homey (ORANGE)

Natural colors bring us to our roots. Throughout the ages browns with a decidedly ruddy undertone have been popular for use within interiors of all types and for homemade crafts. An important artist's color, many painters' palettes feature these rich warm pigments mined from the earth. When paired with white, these terra-cotta shades are the essence of casual elegance reminding one of a perfect cappuccino. Mix with dark chocolate browns and the mood shifts to comforting and warm, like country butter slathered on homemade bread fresh from the toaster on a weekend morning. Use your instincts to expand this natural color; combine with the warmth of sun washed yellows, peaty brown-reds and cooling olive greens for an outdoor woodsy aura.

© David Zaitz/NM-3

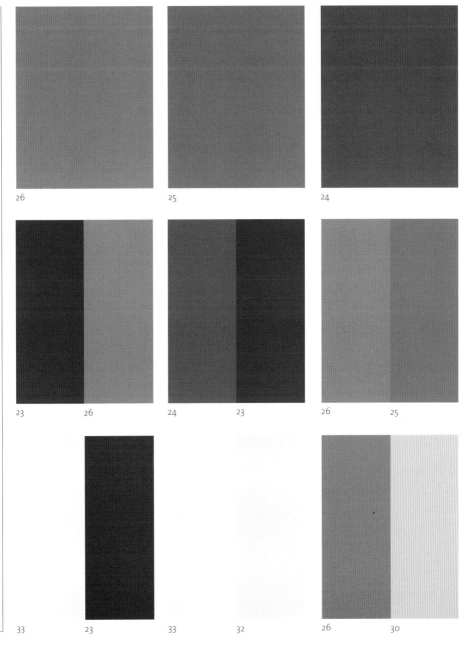

26

25

24

23 26

24 23

26 25

33 23

33 32

26 30

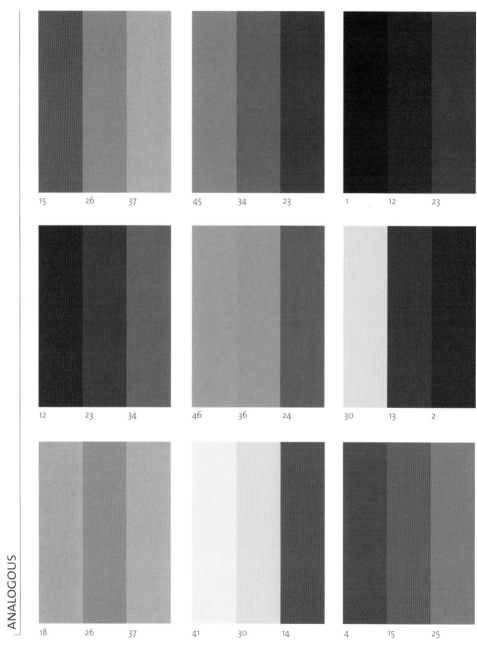

15 26 37 45 34 23 1 12 23

12 23 34 46 36 24 30 13 2

18 26 37 41 30 14 4 15 25

26 89	97 24	23 90

23 79	100 23	85 24

30 103	26 79	109 23

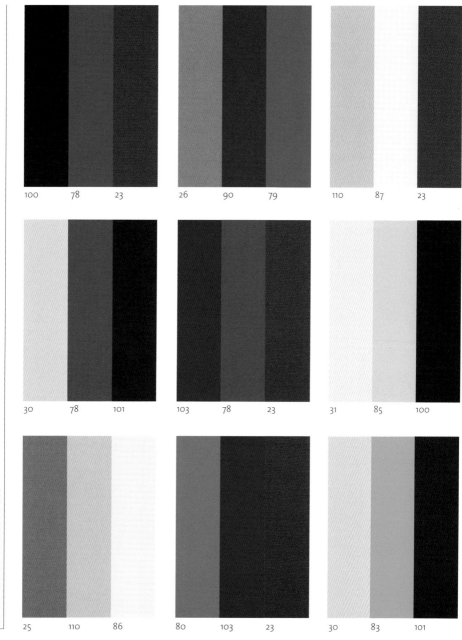

100	78	23
26	90	79
110	87	23

30	78	101
103	78	23
31	85	100

25	110	86
80	103	23
30	83	101

133 26

136 23

140 24

142 26

147 30

23 25

12 23 24

1 26 30

152 25 26

Rugged

Naturals are the fundamental colors of everyday life. Worn, broken-in, and imperfect, these plain, unassuming hues work hard. From the honest earthy color of cobblestones to the rich gold of honey and aged quality of parchment, these simple colors are authentic and warm. When working with brown, black, and yellow-orange shades in a monochromatic color scheme pay close attention to texture. Group natural linens with rough hewn burlap and unbleached cottons for a rustic mood. Give bare wood floors natural warmth and texture with wool rugs and throws. Compose stark winter branches with a sprinkling of bitter orange berries in cream colored jugs for a warmhearted country arrangement.

© Rob Kearney/Photonica

37

36

35

34 37

35 34

36 37

43 35

34 44

43 44

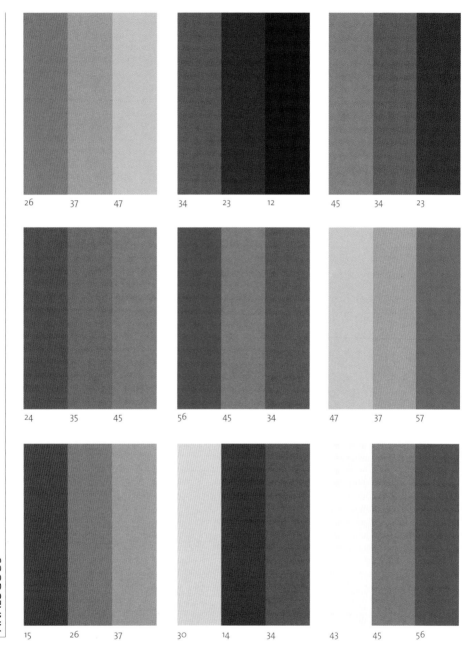

ANALOGOUS

26	37	47
34	23	12
45	34	23

24	35	45
56	45	34
47	37	57

15	26	37
30	14	34
43	45	56

104 37

34 100

35 110

111 37

34 89

35 110

37 89

41 111

89 43

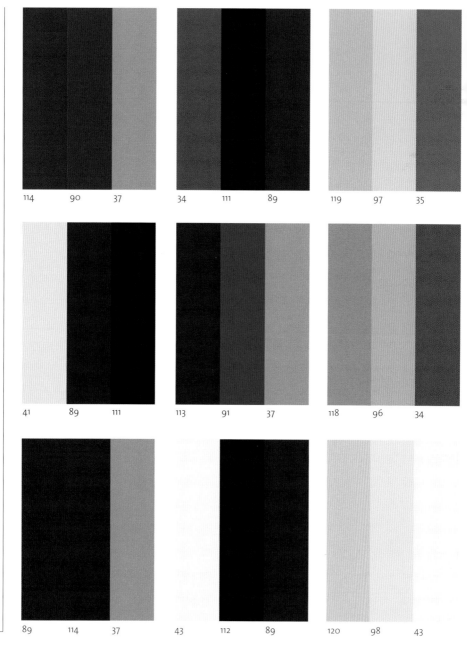

114	90	37
34	111	89
119	97	35

41	89	111
113	91	37
118	96	34

89	114	37
43	112	89
120	98	43

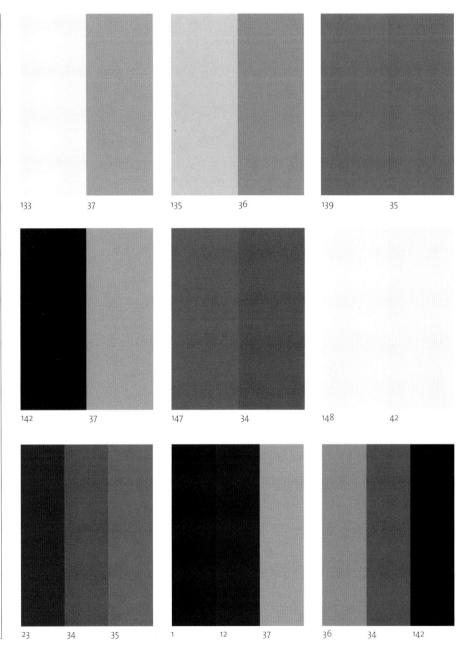

133 37 135 36 139 35

142 37 147 34 148 42

23 34 35 1 12 37 36 34 142

Tranquil
(Gray +Yellow Cast)

Browns and grays with a yellow cast are particularly restful. Together they blend to create the ultimate mood of tranquillity and rest. Compose a serene palette with golds, bitter orange, and buffed whites that bring richness to this sunlit shade while the inherent yellow in this gray tone adds elegance. This harvest color is a reminder of the fading warmth of the autumn sun. The mood of this shade becomes austere and refined when paired with metals and polished woods. When combined with vast amounts of white, this hue has the quality of a sandy shoreline bleached by sun and sea. Add texture with raw linens, wicker, and sisal.

© 35 mm/Photonica

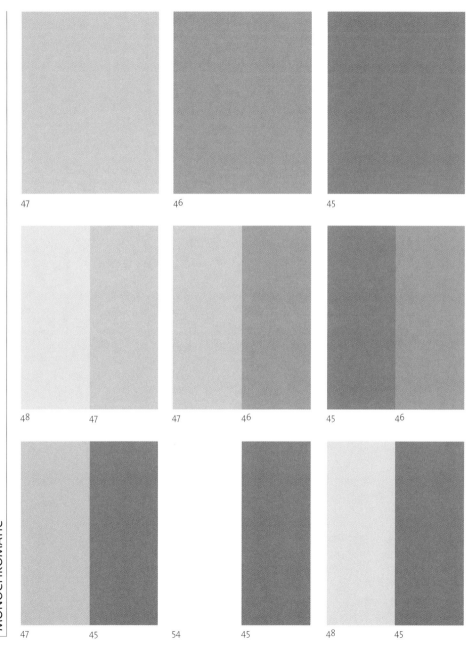

47 46 45

48 47 47 46 45 46

47 45 54 45 48 45

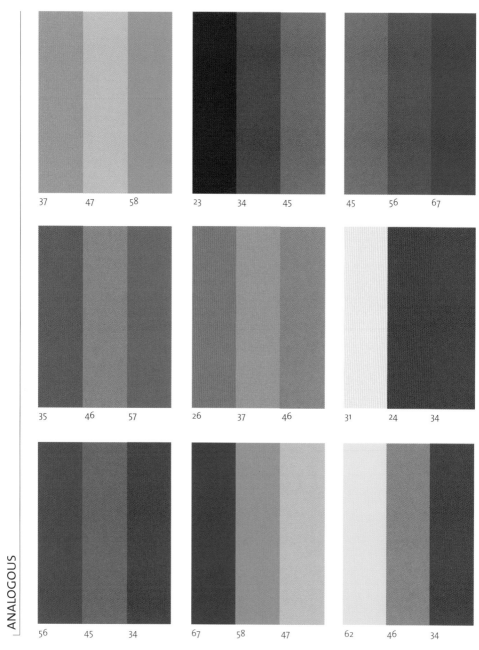

111 45 47 113 114 46

45 122 100 46 123 47

CLASH

108 46 129 45 103 46

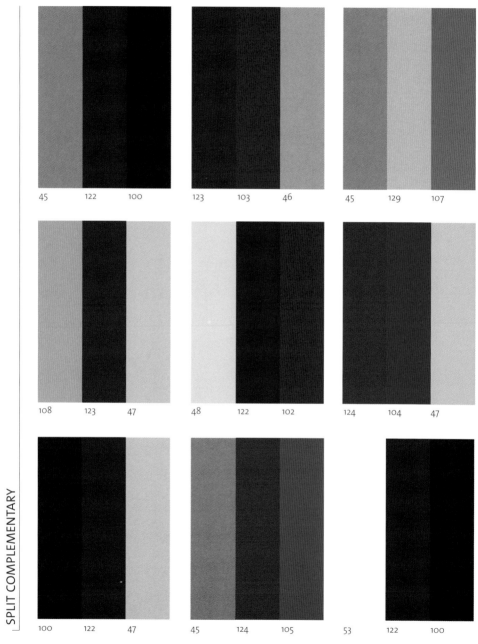

45 122 100

123 103 46

45 129 107

108 123 47

48 122 102

124 104 47

100 122 47

45 124 105

53 122 100

133 48 135 45 137 46

142 46 148 45 152 46

23 39 45 45 46 151 47 1 122

NEUTRAL

Pastoral
(YELLOW—GREEN)

A multitude of yellow-green and its variations are found in the peaceful countryside, proving the infinitely changeable quality of nature. The transforming aspects of color come to life as winter becomes spring and spring changes to summer with each season bringing an endless variety of yellow toned greens from pale tints of chartreuse to deep shades of olive. These peaceful, rustic shades remind one of the importance of local color. One of nature's most prominent colors of renewal and growth, yellow-green is best when combined with other natural hues such as peaty browns, provincial blues, and sun dappled yellows.

© Erik Rank/Photonica

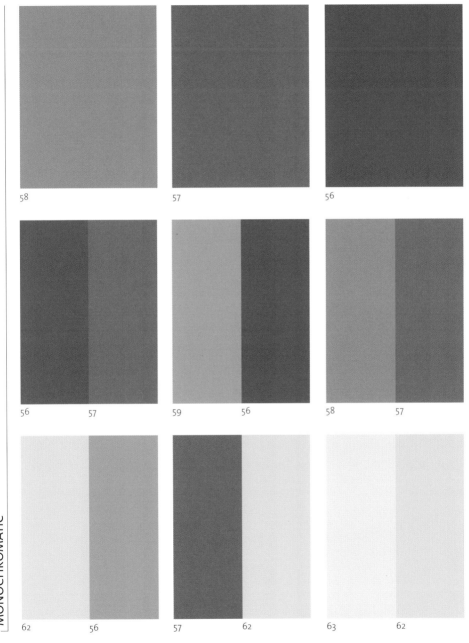

58

57

56

56 57

59 56

58 57

62 56

57 62

63 62

MONOCHROMATIC

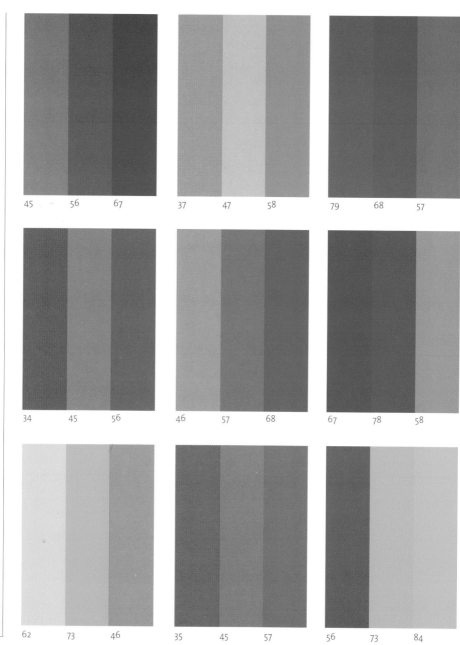

45 56 67

37 47 58

79 68 57

34 45 56

46 57 68

67 78 58

62 73 46

35 45 57

56 73 84

| 122 | 56 | | 58 | 129 | | 123 | 57 |

| 1 | 56 | | 57 | 111 | | 59 | 2 |

| 113 | 57 | | 3 | 56 | | 119 | 57 |

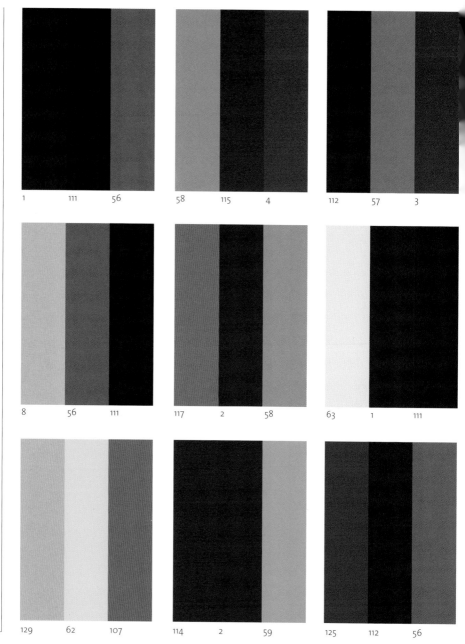

1 111 56	58 115 4	112 57 3
8 56 111	117 2 58	63 1 111
129 62 107	114 2 59	125 112 56

133 58 136 57 139 56

142 58 152 57 1 56

34 23 58 111 122 58 56 57 142

Natural (GREEN)

Many hues of green are distinguished with names from nature such as pine, grass, lime, apple, and mint. All lend their titles and essence to the many variations of green. An enduring outdoor color traditionally associated with the open-air and garden, green is full of life-giving properties. Green is the color of forests, meadows, and rolling hills and is at its best when mixed with dappled yellows, burnt browns, and heavenly blues. Graphic designers often use green to indicate renewal, ecology, and recycling. A secondary hue, green pairs well with its creators blue and yellow, while deep berry pink accents in muted tones add a contemporary flavor. Wherever used, green has a stabilizing peaceful presence—a favorite for corporate interiors, libraries, and studies.

© Sandra Wavrick/Photonica

70 69 68

67 68 74 68 69 70

69 68 74 72 70 72

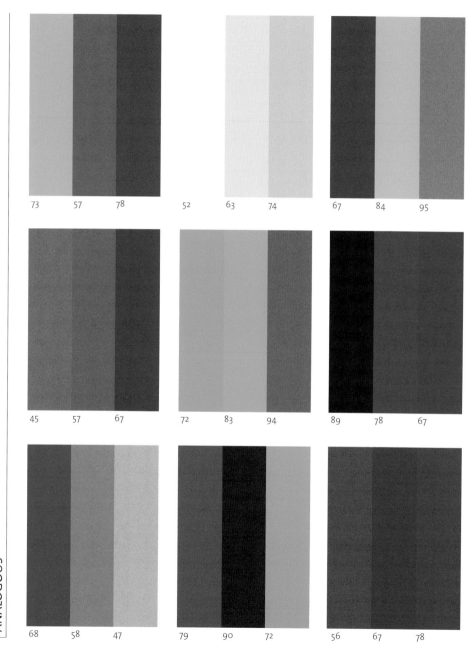

73 57 78

52 63 74

67 84 95

45 57 67

72 83 94

89 78 67

68 58 47

79 90 72

56 67 78

| 1 | 73 | | 68 | 2 | | 3 | 67 |

| 122 | 74 | | 12 | 67 | | 124 | 67 |

| 19 | 73 | | 14 | 67 | | 123 | 75 |

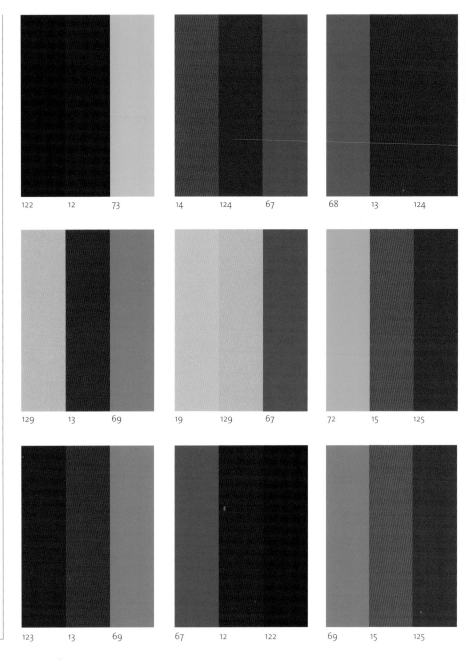

122	12	73
14	124	67
68	13	124

129	13	69
19	129	67
72	15	125

123	13	69
67	12	122
69	15	125

NEUTRAL

133 69 136 68 142 69

144 67 151 73 67 68

100 69 111 122 1 68 12 147 67

Natural (Green) | 59

Clean
(BLUE-GREEN)

Is it blue? Or is it green? True blue-greens are a delicate balance between these two colors, creating the same tension seen between the horizon of a still lake and a clear sky. Clean and watery, this aquamarine color is the basis of many artists' seascapes. A favorite beach color, it's comfortable when combined with unpolished natural elements like driftwood, twine, and rough jute. There is a danger of coastal colors becoming seaside cliché, so consider using with unexpected metallics, futuristic plastics, and dark purples when planning an interior.

©Mitsugu Inada/Photonica

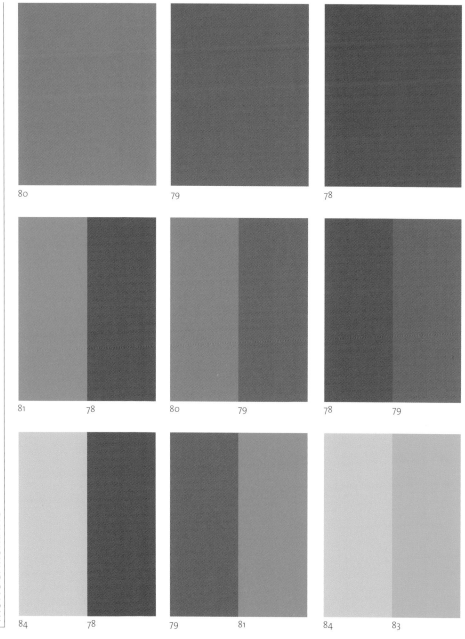

80

79

78

81 78

80 79

78 79

84 78

79 81

84 83

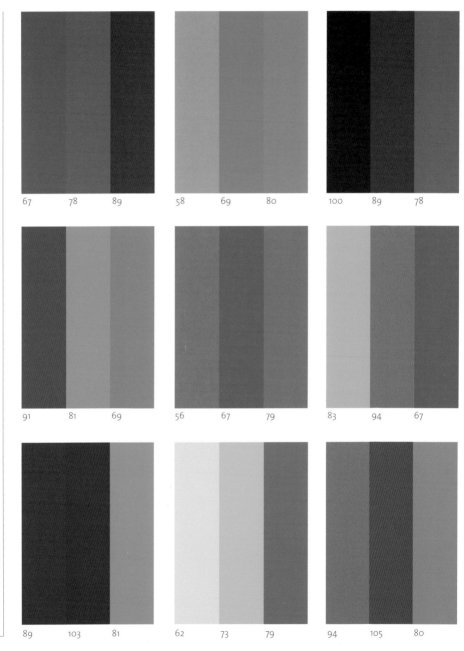

67 78 89 58 69 80 100 89 78

91 81 69 56 67 79 83 94 67

89 103 81 62 73 79 94 105 80

COMPLEMENTARY

13 · 78	80 · 12	14 · 84

25 · 79	1 · 78	83 · 23

CLASH

8 · 79	26 · 80	81 · 4

Clean (Blue-Green) | 63

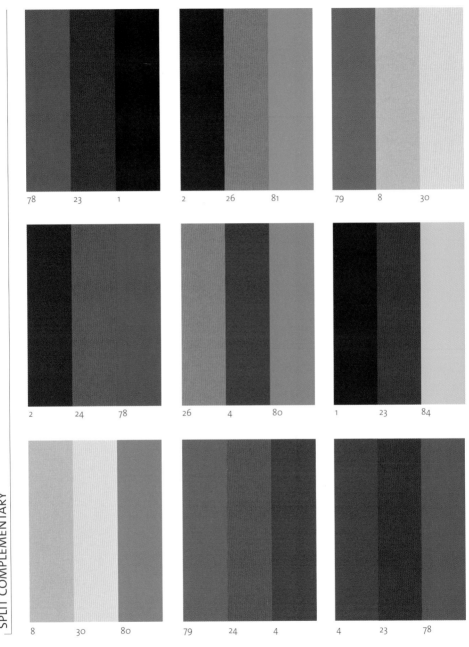

78 23 1

2 26 81

79 8 30

2 24 78

26 4 80

1 23 84

8 30 80

79 24 4

4 23 78

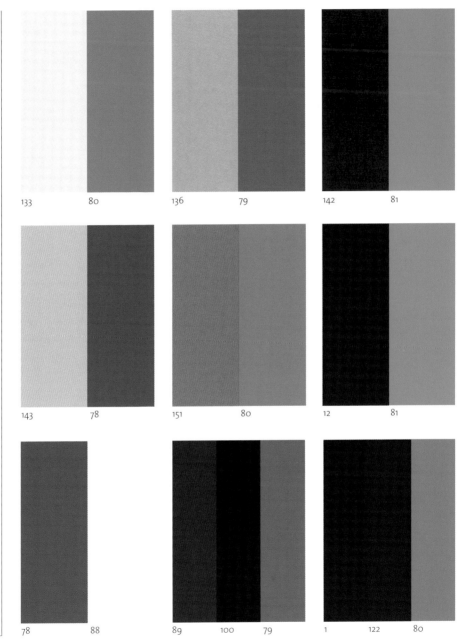

133 80 136 79 142 81

143 78 151 80 12 81

78 88 89 100 79 1 122 80

NEUTRAL

Solid (Blue)

Solid and dependable blue is the most classic hue. Blue is timeless, ageless, incredibly solid, and never out of fashion. From deep indigos to navy blue, this color is at home on land or sea. A sturdy workhorse, blue is a trustworthy color. It's just hard to go wrong with blue. Tonal variations of blue almost always blend remarkably well as evidenced by a favorite pair of jeans. Blue harmonizes with neutrals such as ecru, buff, and creamy tones and is equally happy paired with darker naturals like chocolate brown and warm metallic gray.

© Robbins Cocations/Photonica

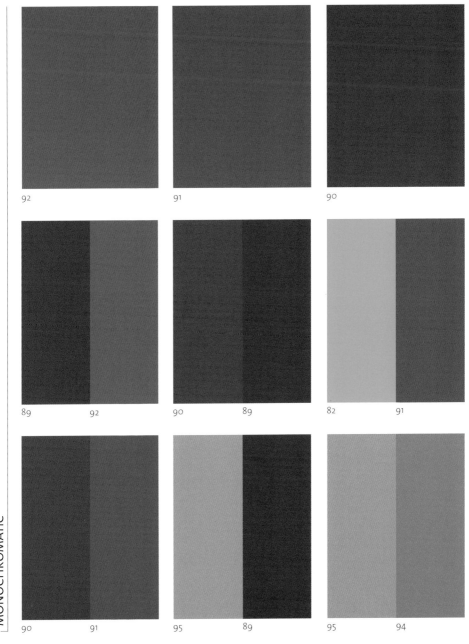

92

91

90

89 92

90 89

82 91

90 91

95 89

95 94

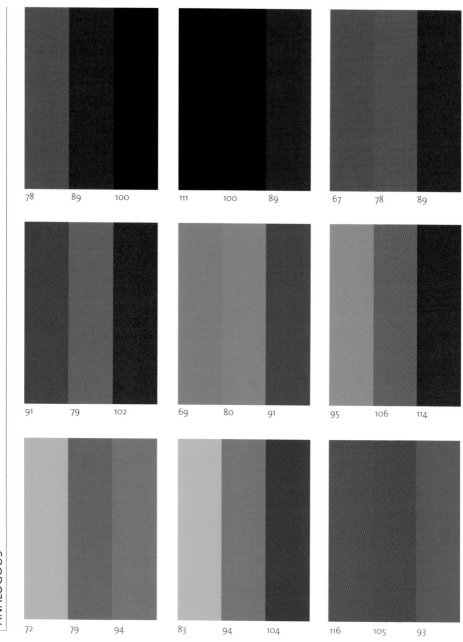

78 89 100 111 100 89 67 78 89

91 79 102 69 80 91 95 106 114

72 79 94 83 94 104 116 105 93

23 89

92 26

24 95

12 90

89 34

14 89

91 37

13 92

89 35

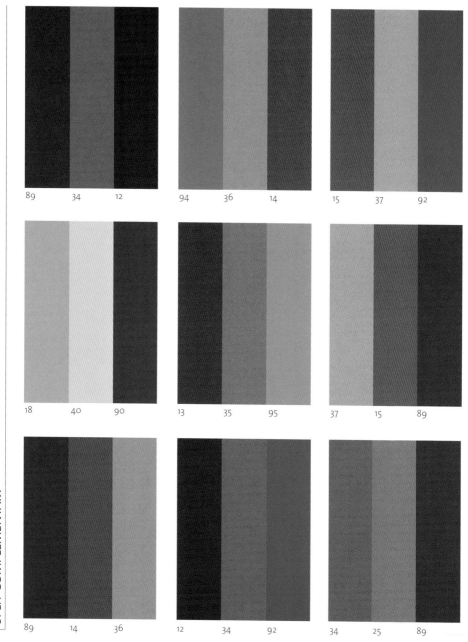

89 34 12 94 36 14 15 37 92

18 40 90 13 35 95 37 15 89

89 14 36 12 34 92 34 25 89

133 90

137 89

139 91

142 91

89 82

147 91

100 11

91

122 1 92

23 34 89

Meditative
(VIOLET)

The pure and elemental colors of stone, sand, sea, and sky inspire soothing and meditative moments. Imagine violet rays of sunlight at the end of day on newly fallen snow, natural colors of light that are almost undefinable. Invoke the calm, cool colors of the planet to create an atmosphere for holistic living. The lavender cast of smooth stones and glassy metals blend well with other cool naturals such as chalky black grays, opaque whites, and the deepest shades of defining black. Bring modern energy to this timeless combination and infuse with intense accents of lime green, amber, or aqua for a shimmering composition of colors.

© 35mm/Photonica

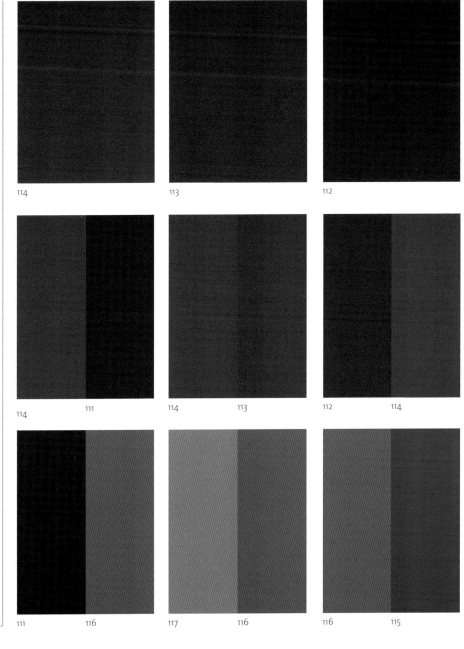

114 113 112

114 111 114 113 112 114

111 116 117 116 116 115

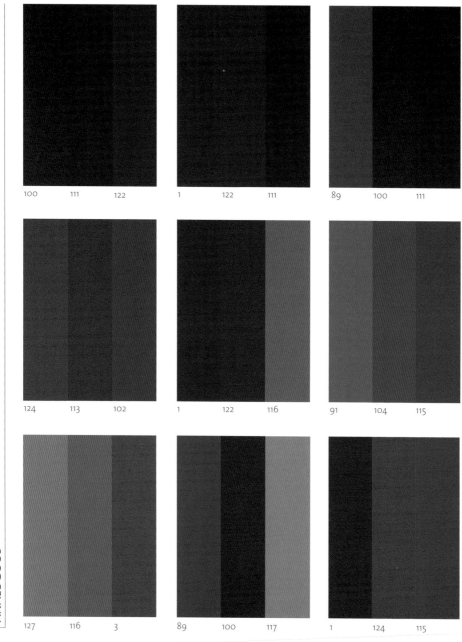

100 111 122

1 122 111

89 100 111

124 113 102

1 122 116

91 104 115

127 116 3

89 100 117

1 124 115

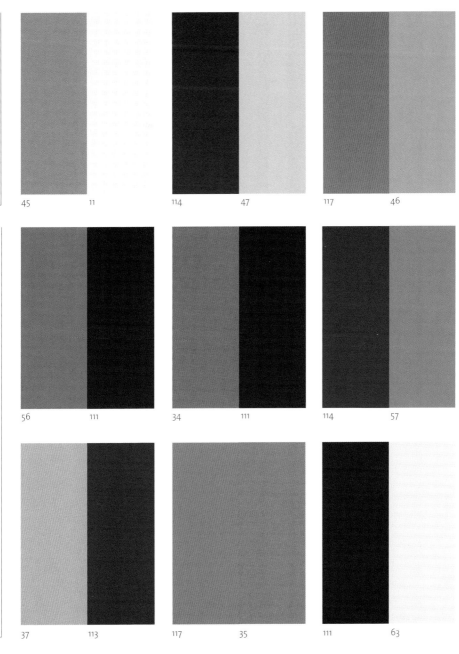

COMPLEMENTARY

45	11
114	47
117	46

56	111
34	111
114	57

CLASH

37	113
117	35
111	63

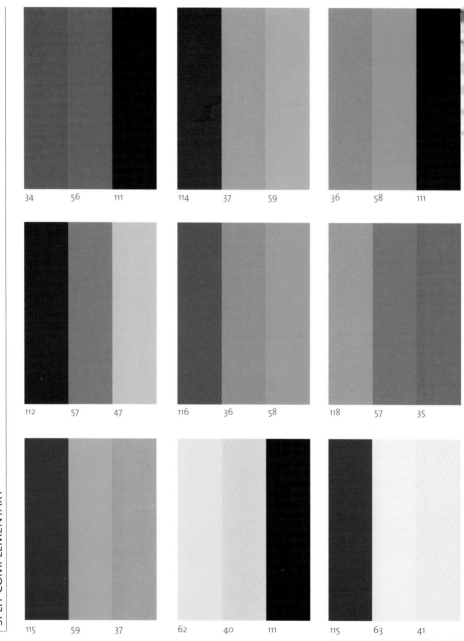

34 56 111

114 37 59

36 58 111

112 57 47

116 36 58

118 57 35

115 59 37

62 40 111

115 63 41

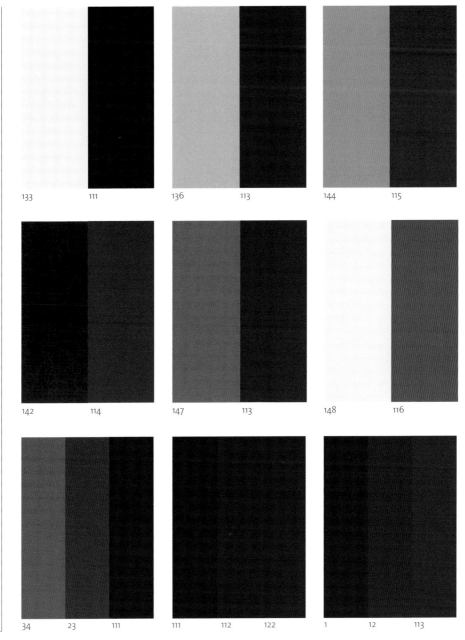

133 111 136 113 144 115

142 114 147 113 148 116

34 23 111 111 112 122 1 12 113

NEUTRAL

Soothing
(Red-Violet)

Nature's mountainous regions rise up to majestically display soothing forms and colors. As natural light shifts and plays, hillsides and mountaintops reveal a spectrum of hues that alternatively calm and buoy. Red combined with violet creates a rich blend known on the color wheel as red-violet. Deeper than a magenta and redder than a plum, this alluring amethyst hue can be softened to a lilac or deepened to a purply black. Warmth-giving yet sedate, comforting yet tinged with excitement, this complex mix draws the eye immediately. While traditionally a regal color, red-violet mixes well with a wide array of neutrals culled from nature including dove grays, ancient antique woods, cool metals, and dark pine greens.

© Shogoro /Photonica

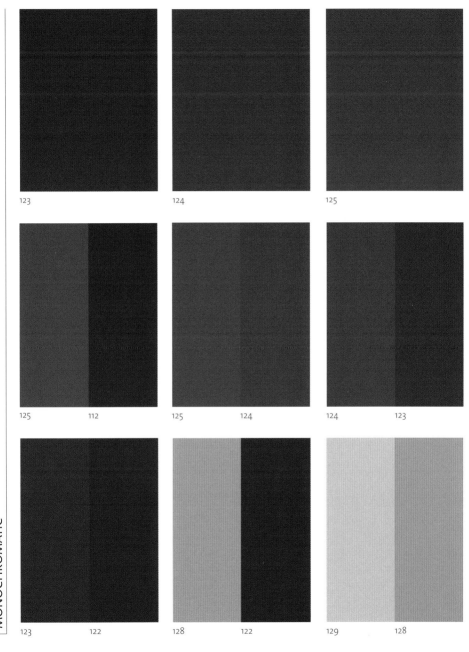

123

124

125

125 112

125 124

124 123

123 122

128 122

129 128

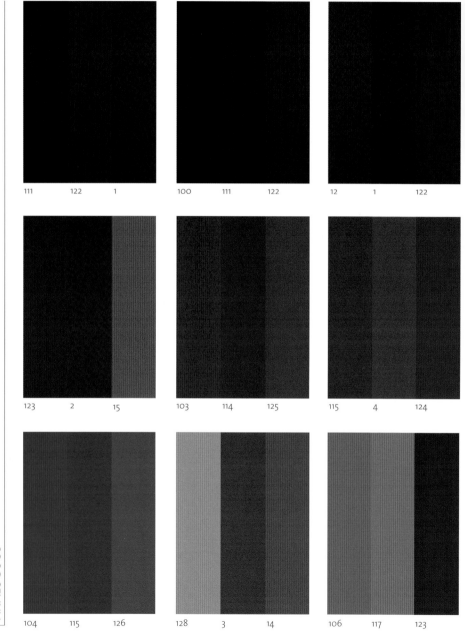

| 111 | 122 | 1 | | 100 | 111 | 122 | | 12 | 1 | 122 |

| 123 | 2 | 15 | | 103 | 114 | 125 | | 115 | 4 | 124 |

| 104 | 115 | 126 | | 128 | 3 | 14 | | 106 | 117 | 123 |

56 122 123 58 57 128

122 67 45 123 125 68

47 124 128 73 46 122

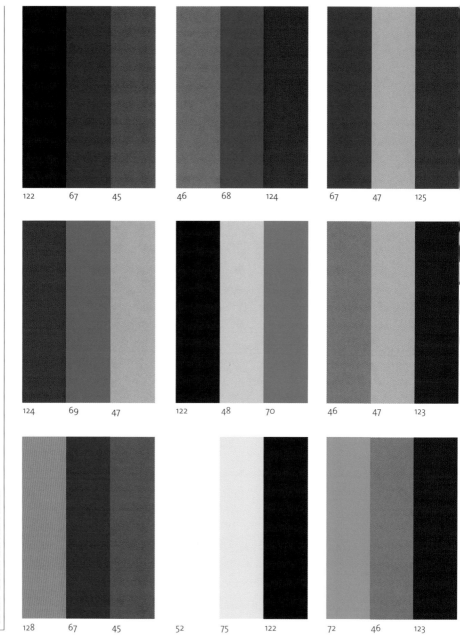

| 122 | 67 | 45 | | 46 | 68 | 124 | | 67 | 47 | 125 |

| 124 | 69 | 47 | | 122 | 48 | 70 | | 46 | 47 | 123 |

| 128 | 67 | 45 | | 52 | 75 | 122 | | 72 | 46 | 123 |

133 122 137 123 142 124

147 125 122 124 152 123

122 1 2 23 34 122 12 23 128

NEUTRAL

Dark

© 35mm/Photonica

Black is the complete absence of light. Cool grays and blacks run the emotional gamut. From utilitarian to evil to elegant, like the night, cool blacks and grays have a blue cast. Colors that are outlined with black (examples are seen in folk or Asian art) visually "pop" because of the high contrast. Calligraphers and the majority of graphic designers use black for all typography in print and online to increase readability, using photography and illustration to create more complex color compositions. Crisp, understated and long wearing, grays and blacks are favorite fashion colors worldwide. Strong cool blacks are often used in advertising and package design to indicate wealth and status.

142

140

137

142 134 133

142 141 140

133 134 142

137 138 139

134 135 140

133 136 137

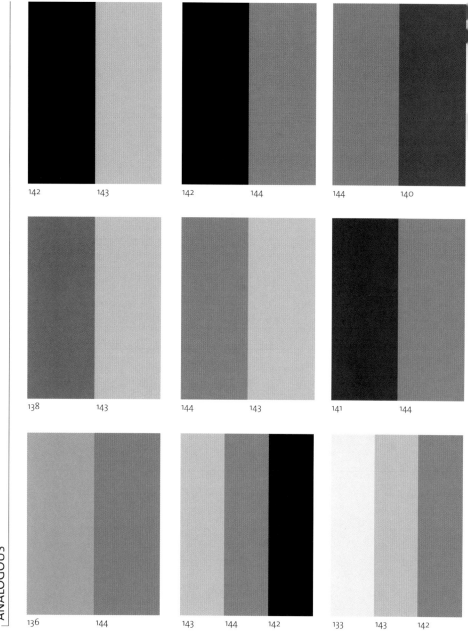

142　　143

142　　144

144　　140

138　　143

144　　143

141　　144

136　　144

143　144　142

133　143　142

142 100

111 100

122 100

111 100

122 111

122 142

111 142

142 122

144 100

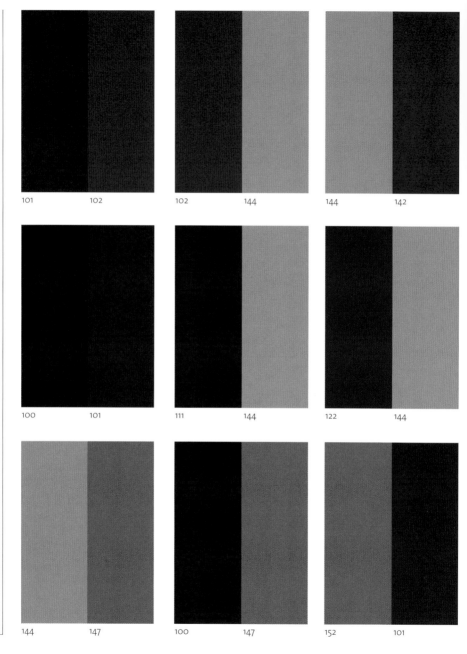

101 102

102 144

144 142

100 101

111 144

122 144

144 147

100 147

152 101

SPLIT COMPLEMENTARY

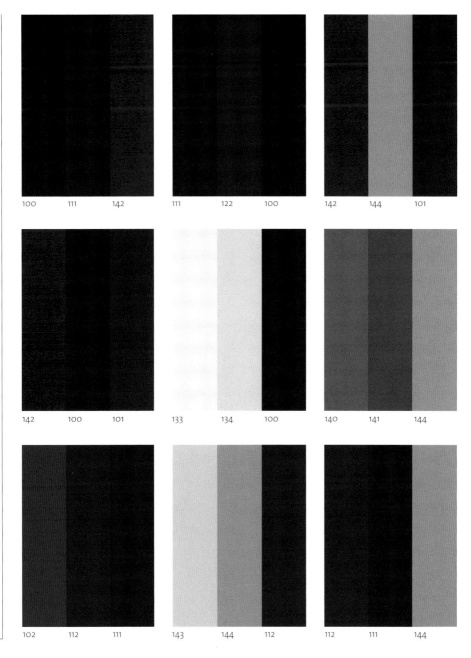

100	111	142
111	122	100
142	144	101

142	100	101
133	134	100
140	141	144

102	112	111
143	144	112
112	111	144

Urban

A favorite with architects, warm gray is often overlooked by the average person. Many interior designers and architects believe the ideal neutral can be achieved by mixing a small amount of red with gray. Evocative and sophisticated, warm gray is an excellent choice for wall color, fabrics, and floor coverings. Grays that have added warmth provide stability to complex color schemes. Warm gray is also successful when used in a monochromatic scheme or as a foundation color from which to build. Too often relegated for use in a polished professional setting, warm gray is a refined neutral with lasting style.

© John Wilkes/Photonica

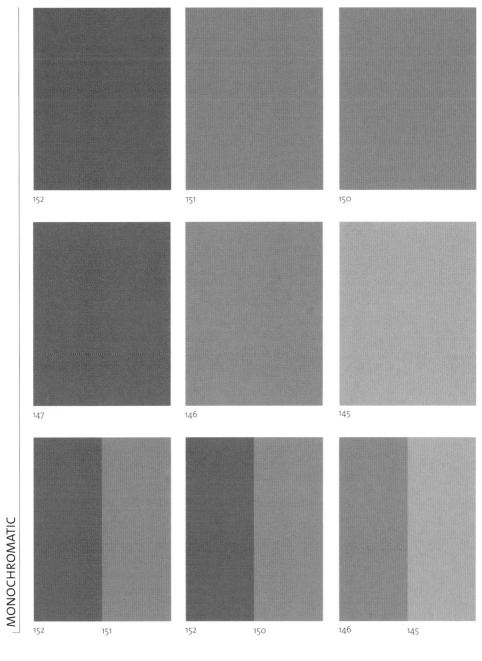

152

151

150

147

146

145

152 151

152 150

146 145

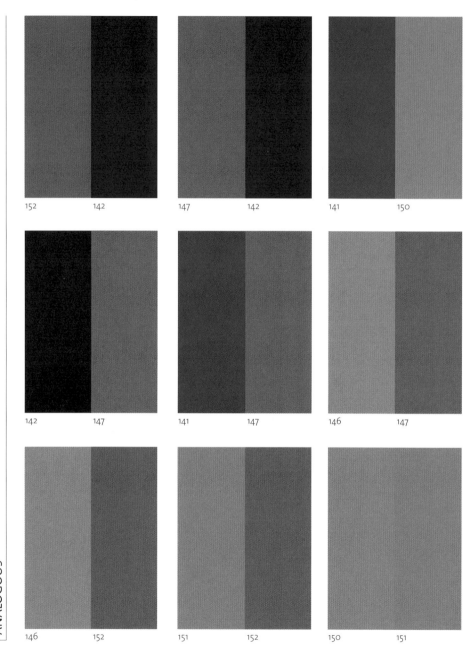

152 142

147 142

141 150

142 147

141 147

146 147

146 152

151 152

150 151

23	142
24	142
34	142
35	142
23	24
24	34

34	35
23	35
23	34

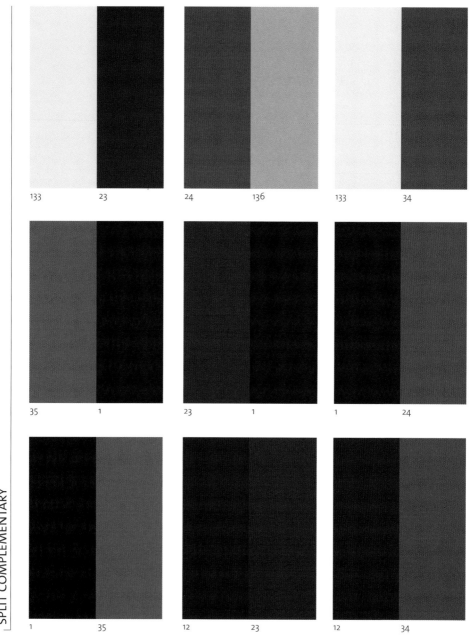

| 133 | 23 | | 24 | 136 | | 133 | 34 |

| 35 | 1 | | 23 | 1 | | 1 | 24 |

| 1 | 35 | | 12 | 23 | | 12 | 34 |

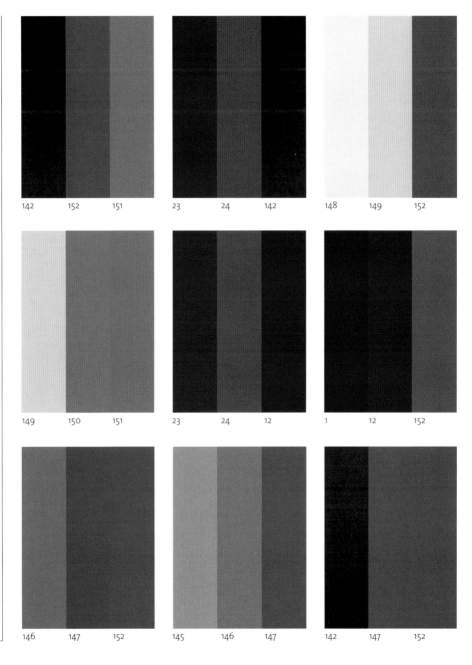

142 152 151 23 24 142 148 149 152

149 150 151 23 24 12 1 12 152

146 147 152 145 146 147 142 147 152

Urban (Warm Gray) | 95

Composed
(Warm White)

Pale, natural shades that feature an orange tint are perfect for interior compositions of form and style. Beautiful when bathed in natural light, these shades and tints are strongly affected by sunlight. Followers of fashion crave the arrival of winter white blends with the softest touch of orange for a warm white hue that brings renewal to any wardrobe during the coldest winter months. Slipcovers, throws, and pillows in natural buff and ecru paired with woven fabrics create the ultimate backdrop for modern life. Compose a structure for a polished corporate interior that requires form, function, and expansiveness by combining bone and biscuit hues with stronger naturals such as gray, black, and steel.

© Jun Yamashita/Photonica

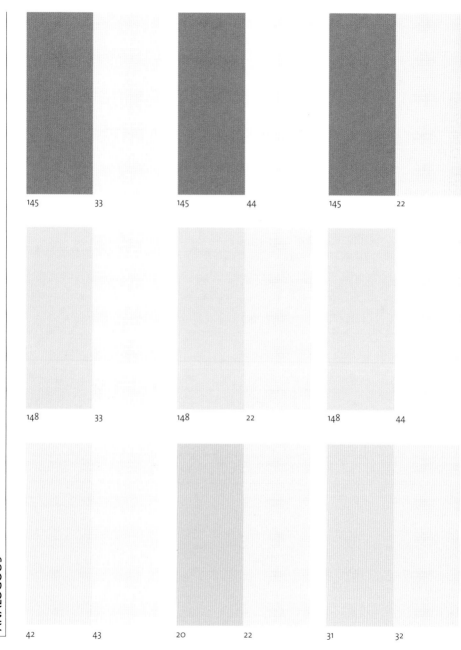

145 33

145 44

145 22

148 33

148 22

148 44

42 43

20 22

31 32

41 42 30 31 41 43

30 32 19 20 19 21

19 30 44 19 43 20

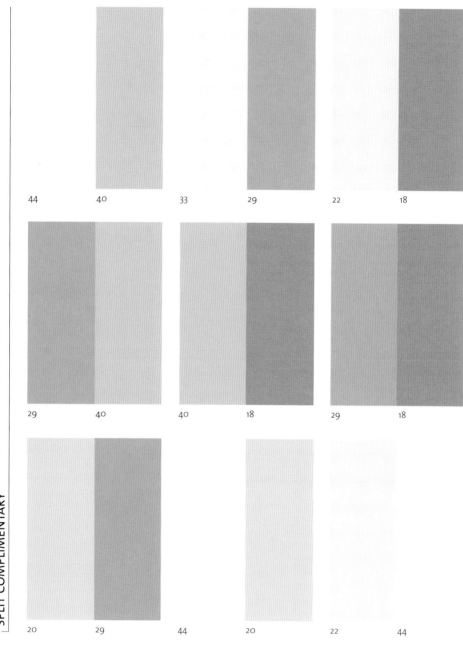

44 40 33 29 22 18

29 40 40 18 29 18

20 29 44 20 22 44

22 33 44 43 32 21 20 31 42

40 41 42 32 31 30 19 20 21

33 23 43 44 43 21 19 20 31

Inspiration

Finding inspiration for a natural palette is quite easy. Look outside. If you are creating a scheme for an interior it is helpful to consider the types of landscapes that you are drawn to and prefe. Or, be aware of the local setting of your home or office and attune the palette to your everyday environment. Inspiration for a natural color palette can be found in the most everyday places. A fallen leaf, dropsof rain, a well trod path, a favorite seashell–when carefully examined all provide infinite variations of color. Nature supplies a seemingly endless supply of terrain, sea, and sky to inspire and motivate.

Look to art movements, time periods, or specific artists for color inspiration. For example, much of the color used by William Morris (a British craftsman, designer, writer, and typographer revered for his work in the field of textiles and wallpapers) reflects the influence of his observations of nature, natural forms, and his knowledge of medieval

© Harriet Zucker/Photonica

works. Morris is known for his late-19th century ground-breaking palette that features a multitude of greens, blues, yellow-golds, and deep reds all linked and influenced by nature. Inspiration for a natural palette can be found by viewing the paintings of landscape artists from Japanese brush painting to the examination of light and its effects on color as interpreted by the Impressionists to the naturalistic influences of the Art Nouveau movement.

Seek inspiration in the symbolic meaning of color as interpreted by various cultures. Western and Eastern cultures have both ascribed great meaning to color in nature. Interestingly, the symbolism of color often has meanings that cut across centuries and cultures. For example, to both Christians and Druids white has symbolized purity. Green has signified renewal and life for many cultures beginning with the ancient Egyptians. Understanding and learning about the many meanings of color can provide the starting point and inspiration to create a harmonious palette for a graphic design, craft, an interior, or project.

Throughout history color schemes based on nature have created palettes that are particularly harmonious. Nature itself provides a logical structure and a sense of order when used as a basis for color selection. Discern and narrow the field of color choices to a specific combination of fluid harmonious colors. Remember, a pleasing arrangement of color should not only engage and but also inspire the viewer. Perhaps the best method of selecting a color palette with a natural focus is to draw inspiration directly from the source–from our planet to the cosmos, you will find countless enduring color combinations that create an inner and outer sense of order.

© Photopix/Photonica

Your Own Moods

Whether you are selecting yarn to knit a sweater or developing a new product, visualize the end result and use color accordingly. You might base your yarn selection on the physical coloring of the recipient, the texture and weight of the yarn, or simply your favorite colors. If you are developing a product, consider where and how it will be used and look to the end use as an indicator for color choice. The environment in which the product will be used is often a good place to begin looking for color inspiration.

Process Color Conversion Chart

COLOR NO.	CYAN C	MAGENTA M	YELLOW Y	BLACK K		COLOR NO.	CYAN C	MAGENTA M	YELLOW Y	BLACK K
1	0	100	100	60		39	0	30	80	0
2	0	100	100	45		40	0	25	60	0
3	0	100	100	25		41	0	15	40	0
4	0	100	100	15		42	0	10	20	0
5	0	100	100	0		43	0	7	17	0
6	0	85	70	0		44	0	5	15	0
7	0	65	50	0		45	0	0	100	55
8	0	45	30	0		46	0	0	100	45
9	0	20	10	0		47	0	0	100	25
10	0	15	8	0		48	0	0	100	15
11	0	10	4	0		49	0	0	100	0
12	0	90	80	60		50	0	0	80	0
13	0	90	80	45		51	0	0	60	0
14	0	90	80	25		52	0	0	40	0
15	0	90	80	15		53	0	0	25	0
16	0	90	80	0		54	0	0	20	0
17	0	70	65	0		55	0	0	15	0
18	0	55	50	0		56	60	0	100	55
19	0	40	35	0		57	60	0	100	45
20	0	20	20	0		58	60	0	100	25
21	0	15	15	0		59	60	0	100	15
22	0	10	10	0		60	60	0	100	0
23	0	60	100	65		61	50	0	80	0
24	0	60	100	45		62	35	0	60	0
25	0	60	100	25		63	25	0	40	0
26	0	60	100	15		64	12	0	20	0
27	0	60	100	0		65	7	0	15	0
28	0	50	80	0		66	5	0	13	0
29	0	40	60	0		67	100	0	90	55
30	0	25	40	0		68	100	0	90	45
31	0	15	20	0		69	100	0	90	25
32	0	10	15	0		70	100	0	90	15
33	0	7	12	0		71	100	0	90	0
34	0	40	100	55		72	80	0	75	0
35	0	40	100	45		73	60	0	55	0
36	0	40	100	25		74	45	0	35	0
37	0	40	100	15		75	25	0	20	0
38	0	40	100	0		76	20	15	0	0

COLOR NO.	CYAN C	MAGENTA M	YELLOW	BLACK K		COLOR NO.	CYAN C	MAGENTA M	YELLOW	BLACK K
77	15	10	0	0		96	50	25	0	0
78	100	0	40	55		97	30	15	0	0
79	100	0	40	45		98	25	10	0	0
80	100	0	40	25		99	20	5	0	0
81	100	0	40	15		100	100	90	0	55
82	100	0	40	0		101	100	90	0	45
83	80	0	30	0		102	100	90	0	25
84	60	0	25	0		103	100	90	0	15
85	45	0	20	0		104	100	90	0	0
86	25	0	10	0		105	85	80	0	0
87	20	0	5	0		106	75	65	0	0
88	15	0	3	0		107	60	55	0	0
89	100	60	0	55		108	45	40	0	0
90	100	60	0	45		109	35	30	0	0
91	100	60	0	25		110	30	25	0	0
92	100	60	0	15		111	80	100	0	55
93	100	60	0	0		112	80	100	0	45
94	85	50	0	0		113	80	100	0	25
95	65	40	0	0		114	80	100	0	15

COLOR NO.	CYAN C	MAGENTA M	YELLOW	BLACK K
115	80	100	0	0
116	65	85	0	0
117	55	65	0	0
118	40	50	0	0
119	25	30	0	0
120	20	25	0	0
121	15	20	0	0
122	40	100	0	55
123	40	100	0	45
124	40	100	0	25
125	40	100	0	15
126	40	100	0	0
127	35	80	0	0
128	25	60	0	0
129	20	40	0	0
130	10	20	0	0
131	8	15	0	0
132	5	10	0	0
133	0	0	0	10

COLOR NO.	CYAN C	MAGENTA M	YELLOW
134	0	0	0
135	0	0	0
136	0	0	0
137	0	0	0
138	0	0	0
139	0	0	0
140	0	0	0
141	0	0	0
142	0	0	0
143	15	10	10
144	35	20	20
145	3	15	3
146	10	20	10
147	10	40	10
148	5	5	20
149	10	10	35
150	30	30	55
151	35	30	60
152	40	40	90

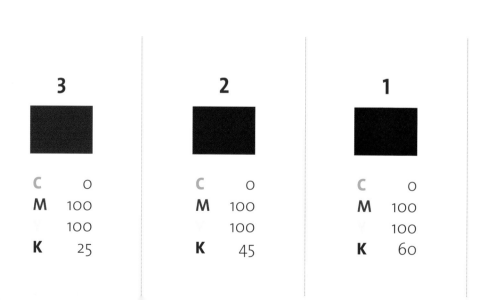

3

C 0
M 100
100
K 25

2

C 0
M 100
100
K 45

1

C 0
M 100
100
K 60

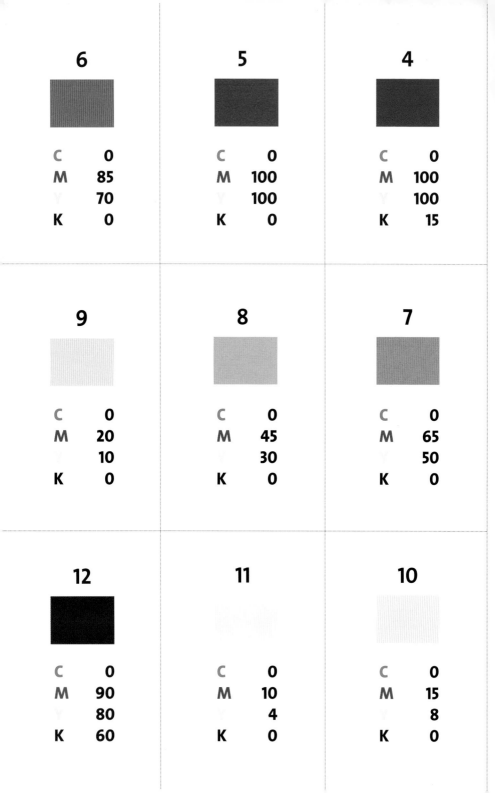

6

C	0
M	85
Y	70
K	0

5

C	0
M	100
Y	100
K	0

4

C	0
M	100
Y	100
K	15

9

C	0
M	20
Y	10
K	0

8

C	0
M	45
Y	30
K	0

7

C	0
M	65
Y	50
K	0

12

C	0
M	90
Y	80
K	60

11

C	0
M	10
Y	4
K	0

10

C	0
M	15
Y	8
K	0

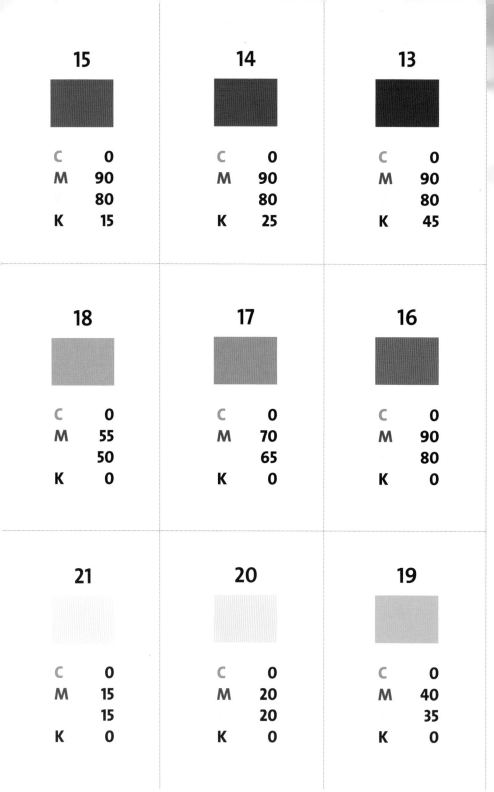

15

C	0
M	90
	80
K	15

14

C	0
M	90
	80
K	25

13

C	0
M	90
	80
K	45

18

C	0
M	55
	50
K	0

17

C	0
M	70
	65
K	0

16

C	0
M	90
	80
K	0

21

C	0
M	15
	15
K	0

20

C	0
M	20
	20
K	0

19

C	0
M	40
	35
K	0

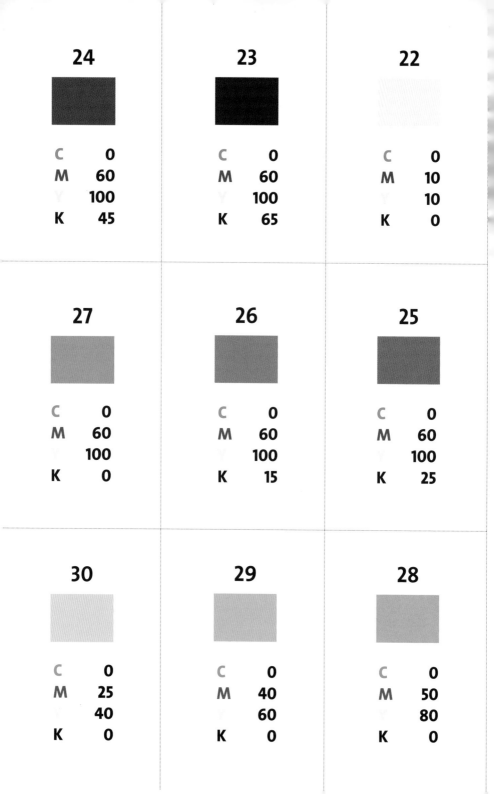

24

C	0
M	60
Y	100
K	45

23

C	0
M	60
Y	100
K	65

22

C	0
M	10
Y	10
K	0

27

C	0
M	60
Y	100
K	0

26

C	0
M	60
Y	100
K	15

25

C	0
M	60
Y	100
K	25

30

C	0
M	25
Y	40
K	0

29

C	0
M	40
Y	60
K	0

28

C	0
M	50
Y	80
K	0

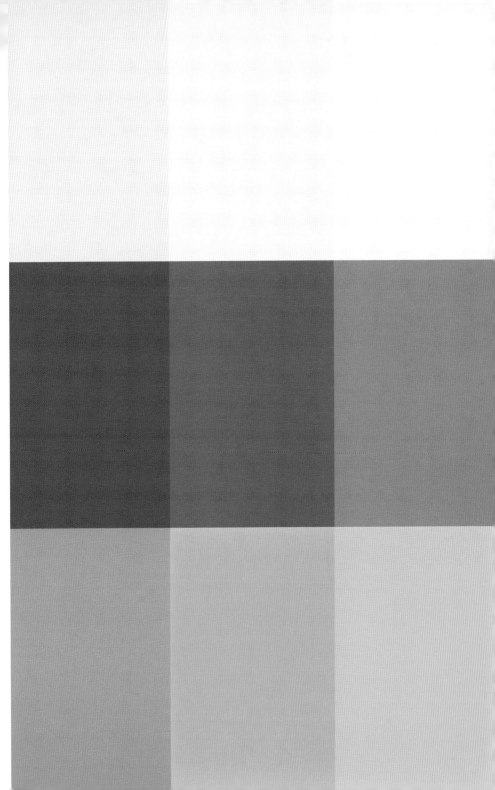

33	32	31
C 0	C 0	C 0
M 7	M 10	M 15
12	15	20
K 0	K 0	K 0

36	35	34
C 0	C 0	C 0
M 40	M 40	M 40
100	100	100
K 25	K 45	K 55

39	38	37
C 0	C 0	C 0
M 30	M 40	M 40
80	100	100
K 0	K 0	K 15

42

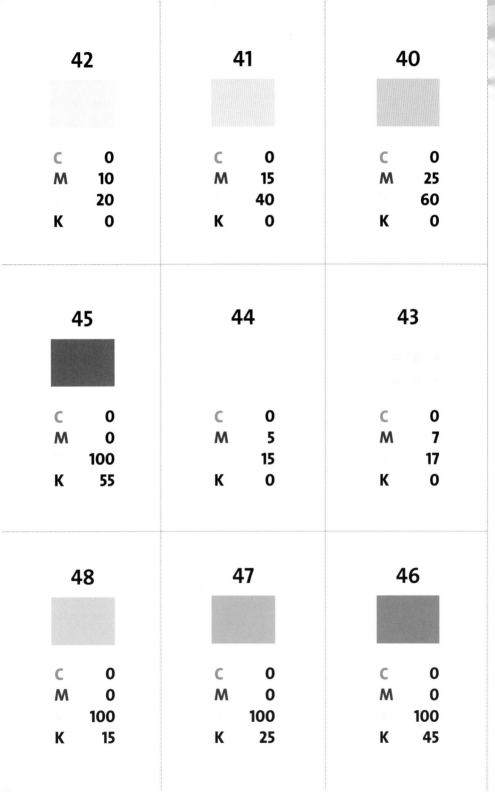

C	0
M	10
	20
K	0

41

C	0
M	15
	40
K	0

40

C	0
M	25
	60
K	0

45

C	0
M	0
	100
K	55

44

C	0
M	5
	15
K	0

43

C	0
M	7
	17
K	0

48

C	0
M	0
	100
K	15

47

C	0
M	0
	100
K	25

46

C	0
M	0
	100
K	45

51

C 0
M 0
 60
K 0

50

C 0
M 0
 80
K 0

49

C 0
M 0
 100
K 0

54

C 0
M 0
 20
K 0

53

C 0
M 0
 25
K 0

52

C 0
M 0
 40
K 0

57

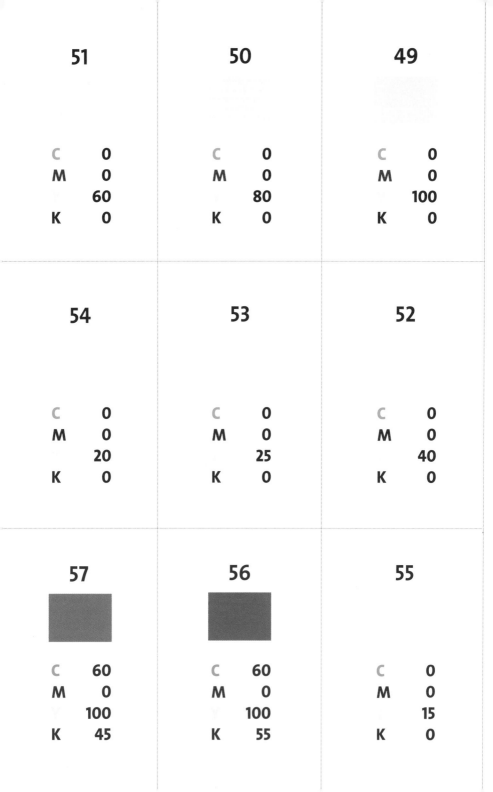

C 60
M 0
 100
K 45

56

C 60
M 0
 100
K 55

55

C 0
M 0
 15
K 0

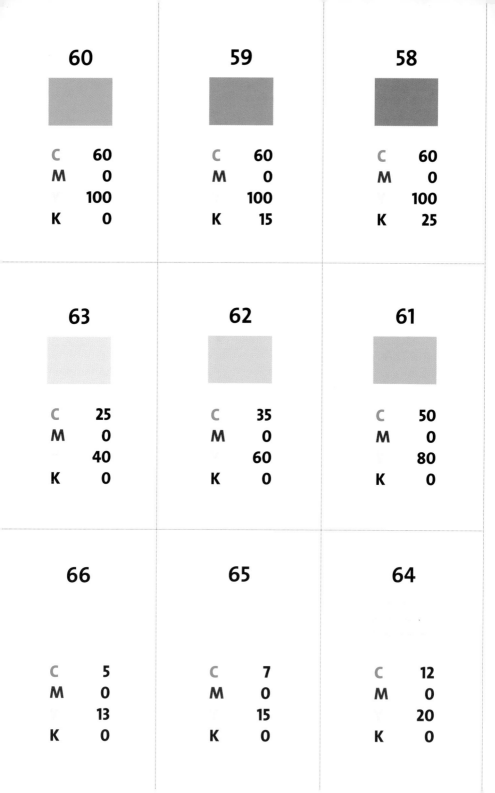

60

C 60
M 0
 100
K 0

59

C 60
M 0
 100
K 15

58

C 60
M 0
 100
K 25

63

C 25
M 0
 40
K 0

62

C 35
M 0
 60
K 0

61

C 50
M 0
 80
K 0

66

C 5
M 0
 13
K 0

65

C 7
M 0
 15
K 0

64

C 12
M 0
 20
K 0

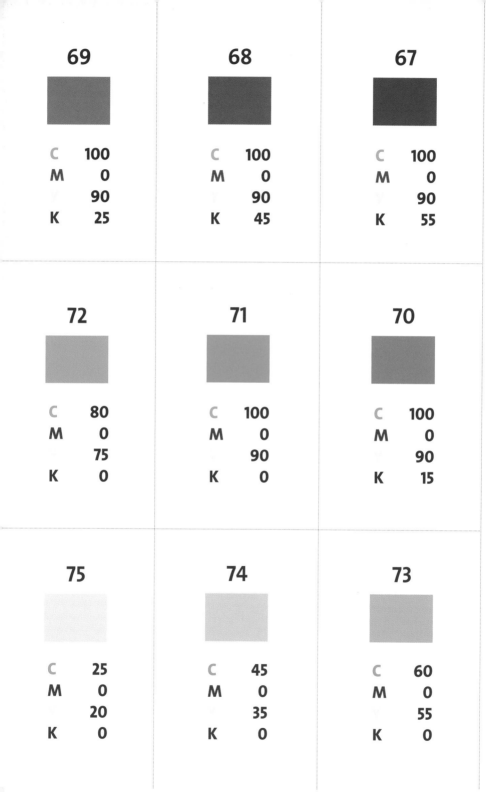

69

C 100
M 0
90
K 25

68

C 100
M 0
90
K 45

67

C 100
M 0
90
K 55

72

C 80
M 0
75
K 0

71

C 100
M 0
90
K 0

70

C 100
M 0
90
K 15

75

C 25
M 0
20
K 0

74

C 45
M 0
35
K 0

73

C 60
M 0
55
K 0

78

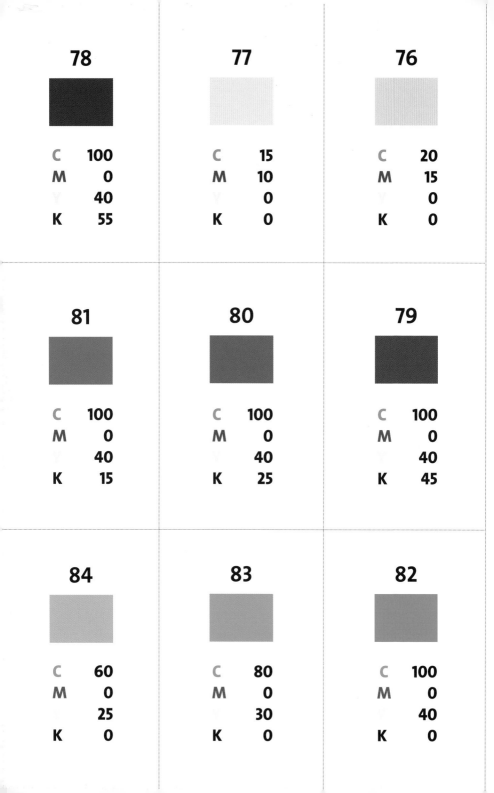

C 100
M 0
 40
K 55

77

C 15
M 10
 0
K 0

76

C 20
M 15
 0
K 0

81

C 100
M 0
 40
K 15

80

C 100
M 0
 40
K 25

79

C 100
M 0
 40
K 45

84

C 60
M 0
 25
K 0

83

C 80
M 0
 30
K 0

82

C 100
M 0
 40
K 0

87

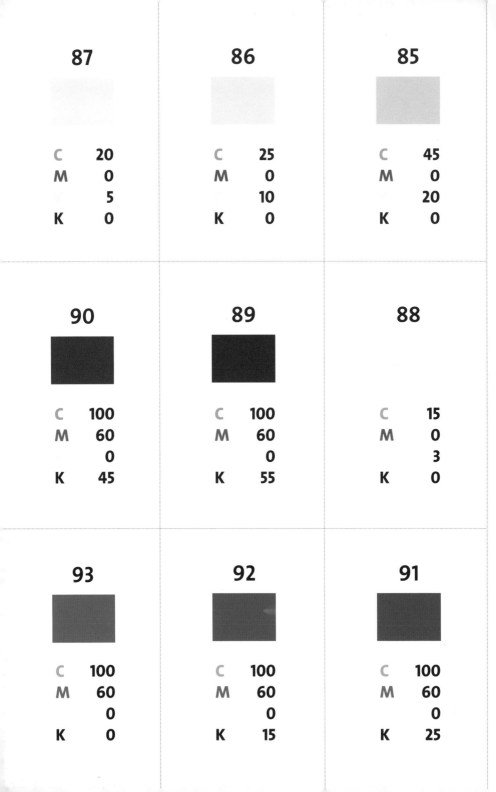

C	20
M	0
	5
K	0

86

C	25
M	0
	10
K	0

85

C	45
M	0
	20
K	0

90

C	100
M	60
	0
K	45

89

C	100
M	60
	0
K	55

88

C	15
M	0
	3
K	0

93

C	100
M	60
	0
K	0

92

C	100
M	60
	0
K	15

91

C	100
M	60
	0
K	25

96

C 50
M 25
Y 0
K 0

95

C 65
M 40
Y 0
K 0

94

C 85
M 50
Y 0
K 0

99

C 20
M 5
Y 0
K 0

98

C 25
M 10
Y 0
K 0

97

C 30
M 15
Y 0
K 0

102

C 100
M 90
Y 0
K 25

101

C 100
M 90
Y 0
K 45

100

C 100
M 90
Y 0
K 55

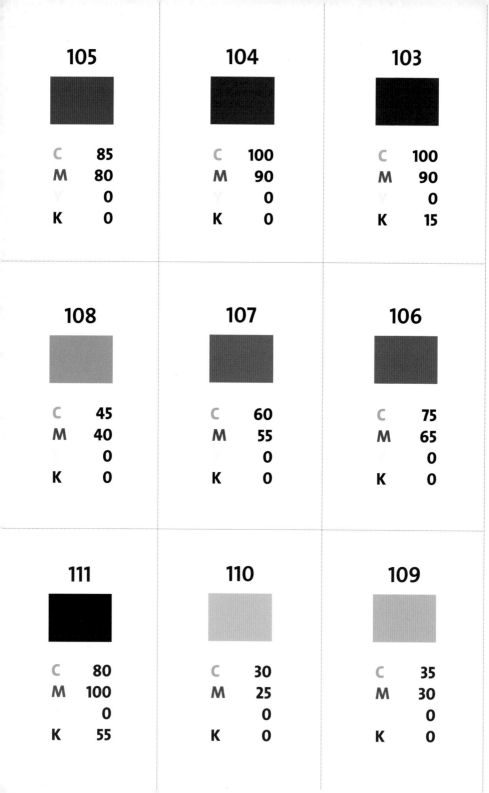

105

C 85
M 80
Y 0
K 0

104

C 100
M 90
Y 0
K 0

103

C 100
M 90
Y 0
K 15

108

C 45
M 40
Y 0
K 0

107

C 60
M 55
Y 0
K 0

106

C 75
M 65
Y 0
K 0

111

C 80
M 100
Y 0
K 55

110

C 30
M 25
Y 0
K 0

109

C 35
M 30
Y 0
K 0

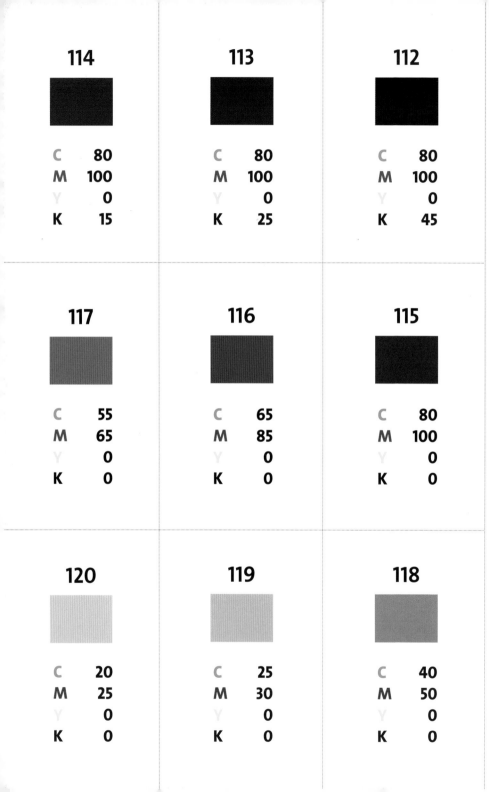

114

C	80
M	100
Y	0
K	15

113

C	80
M	100
Y	0
K	25

112

C	80
M	100
Y	0
K	45

117

C	55
M	65
Y	0
K	0

116

C	65
M	85
Y	0
K	0

115

C	80
M	100
Y	0
K	0

120

C	20
M	25
Y	0
K	0

119

C	25
M	30
Y	0
K	0

118

C	40
M	50
Y	0
K	0

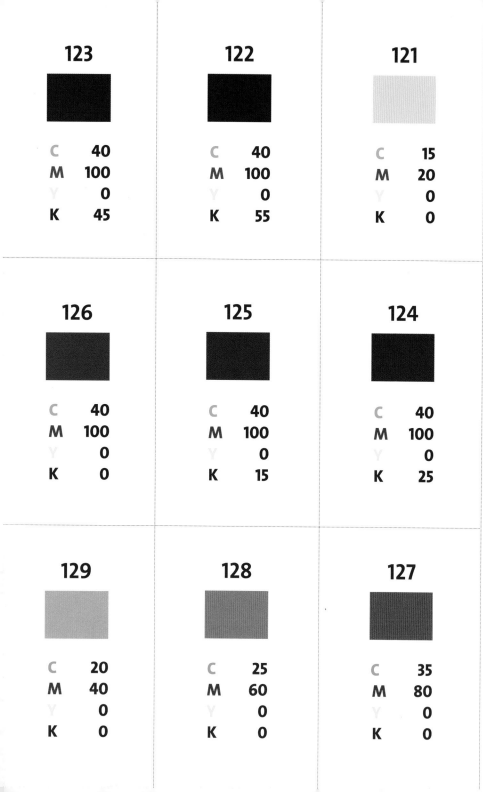

123

C 40
M 100
Y 0
K 45

122

C 40
M 100
Y 0
K 55

121

C 15
M 20
Y 0
K 0

126

C 40
M 100
Y 0
K 0

125

C 40
M 100
Y 0
K 15

124

C 40
M 100
Y 0
K 25

129

C 20
M 40
Y 0
K 0

128

C 25
M 60
Y 0
K 0

127

C 35
M 80
Y 0
K 0

132

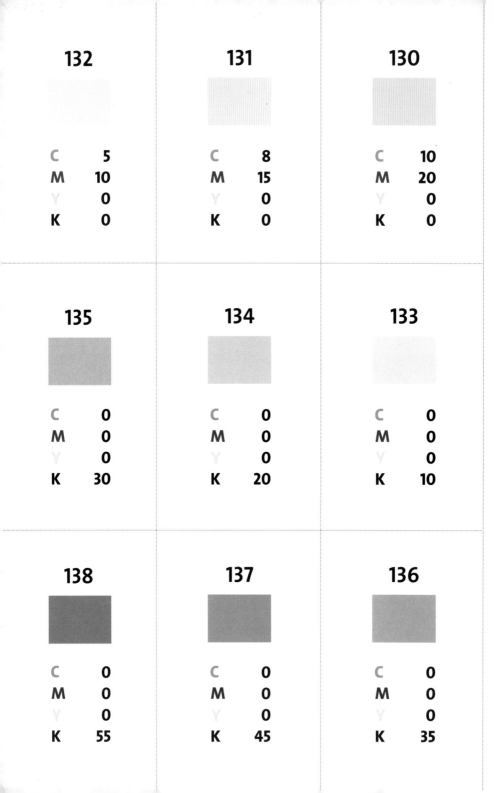

C	5
M	10
Y	0
K	0

131

C	8
M	15
Y	0
K	0

130

C	10
M	20
Y	0
K	0

135

C	0
M	0
Y	0
K	30

134

C	0
M	0
Y	0
K	20

133

C	0
M	0
Y	0
K	10

138

C	0
M	0
Y	0
K	55

137

C	0
M	0
Y	0
K	45

136

C	0
M	0
Y	0
K	35

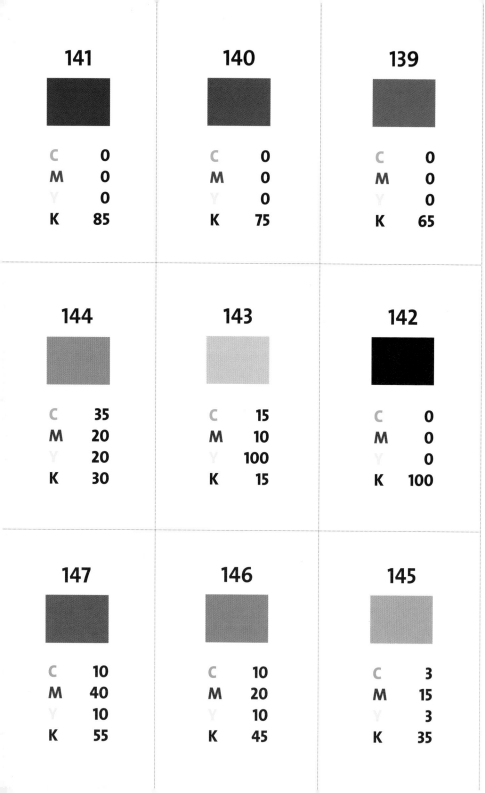

141
C 0
M 0
Y 0
K 85

140
C 0
M 0
Y 0
K 75

139
C 0
M 0
Y 0
K 65

144
C 35
M 20
Y 20
K 30

143
C 15
M 10
Y 100
K 15

142
C 0
M 0
Y 0
K 100

147
C 10
M 40
Y 10
K 55

146
C 10
M 20
Y 10
K 45

145
C 3
M 15
Y 3
K 35

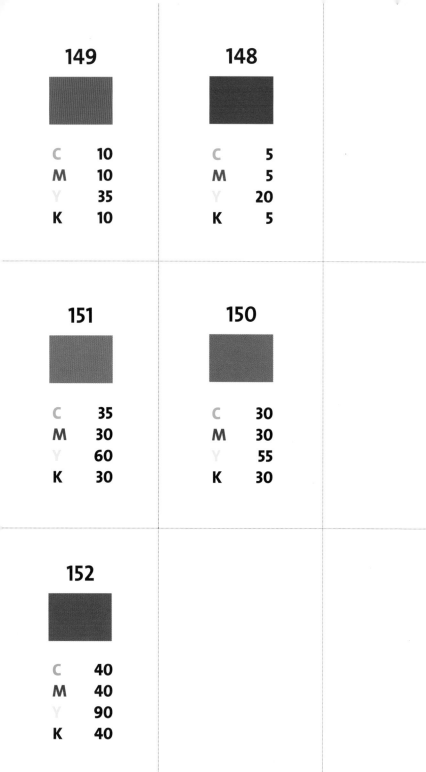

149

C 10
M 10
Y 35
K 10

148

C 5
M 5
Y 20
K 5

151

C 35
M 30
Y 60
K 30

150

C 30
M 30
Y 55
K 30

152

C 40
M 40
Y 90
K 40

About the Author

Martha Gill is a freelance graphic designer, spokesperson and entrepreneur. She is the author and designer of the *Modern Lifestyle Guides* a book series created for people with more style than time. Martha has received national recognition with features in the *Chicago Tribune, New York Daily News, LA Times, InStyle* and on *E!'s Style Network*. She lives with her husband and two children in Atlanta, Georgia.